Bait

THE TOAD

by KENDRA POWERS

**published by PowersSquared,
an imprint of Catalyst Press**
Orono, Maine

For further information, write info@catalystpress.org
In North America, this book is distributed by
Consortium Book Sales & Distribution, a division of Ingram.
Phone: 612/746-2600
cbsdinfo@ingramcontent.com
www.cbsd.com
In South Africa, Namibia, and Botswana,
this book is distributed by Protea Distribution.
For information, email orders@proteadistribution.co.za.
FIRST EDITION
10 9 8 7 6 5 4 3 2 1
ISBN 9781733547451
Library of Congress Control Number: 2023932100

For my friend Armani because
she really likes Bait and Bait loves her.
And for my Grandma and Grandpa Powers,
my Auntie Jess, and my cousin Nesta.

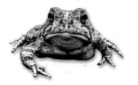

Photographer Kendra Powers

The summer I was twelve, my cousin Nesta and I went wading in a local river. We kept seeing baby toads jumping around, so we caught a bunch of them and took them home. Back when I was five, my mom caught a toad in our yard and taught me how to take care of it – like what it needed to eat and live, to always wash my hands before and after touching it, and to never handle it when it was shedding its skin.

So, I made an aquarium for these baby toads in a clear plastic box and poked air holes in the lid. I put in rocks, dirt, plants, and a wading pool, and I made places where the baby toads could hide. I also put a light above the aquarium so they could sunbathe.

To feed them, I put squashed marshmallows outdoors to attract ants, shook the ants into a jar and dumped them into the aquarium. One toad started eating more ants than the others. That was Bait. He grew bigger and bigger, and the other toads disappeared.

I bought fake plants for Bait's aquarium at a craft store. Then I made him little hidey houses out of pebbles. I hot-glued pebbles around the edge of a round plastic lid, leaving space for a door. Then I hot-glued rows of pebbles, round and round, up into a tiny stone igloo. I made a swing, too. I crocheted strings, attached them to a small plastic box with low sides, and then tied them to the aquarium lid. Bait hopped in.

I cleaned Bait's aquarium and water bowl, gave him fresh water, and fed him. The more I fed Bait, the more comfortable he got with me. So, I started taking him on walks.

Bait has the prettiest eyes. I started taking photos of him on our walks. Then I used colored polymer clay to make him hats. When I posted my pictures on Tik Tok, my friends started watching them. Other people liked them, too.

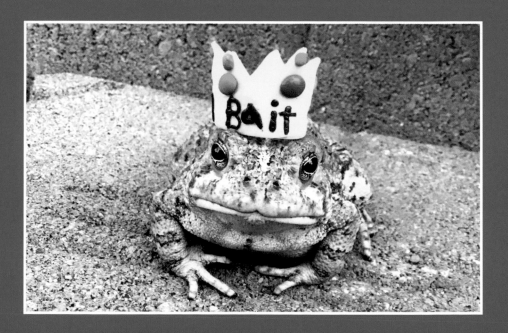

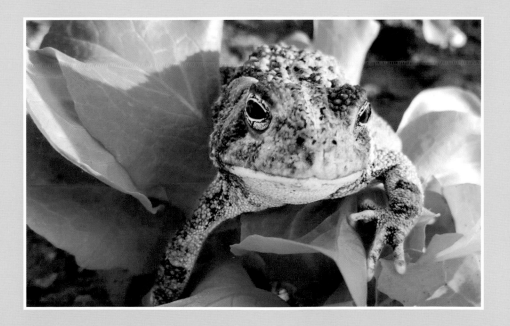

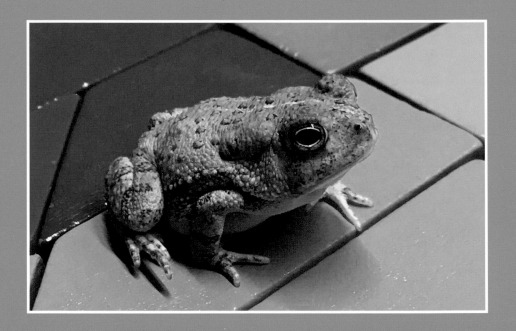

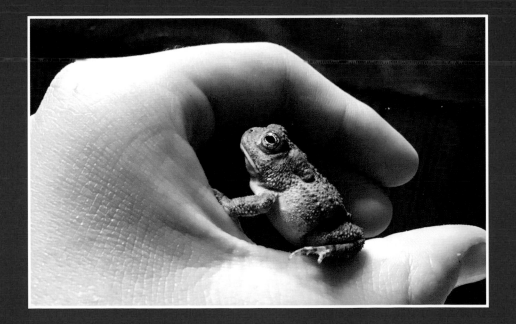

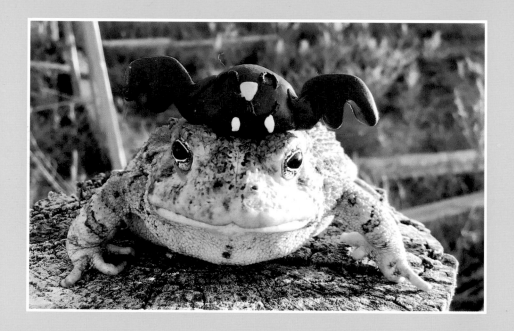

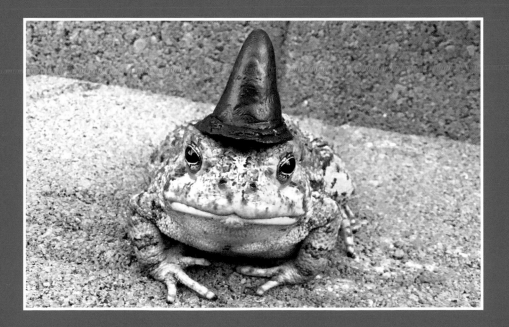

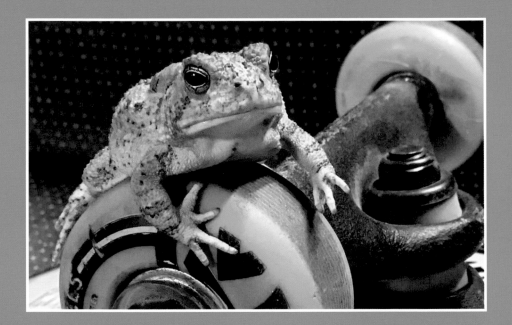

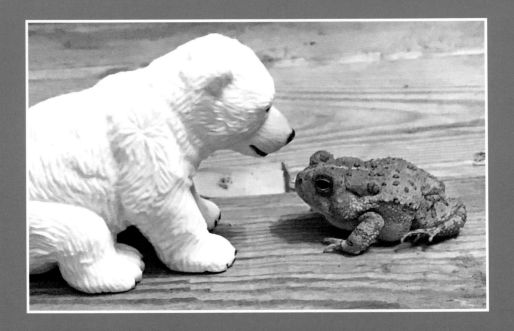

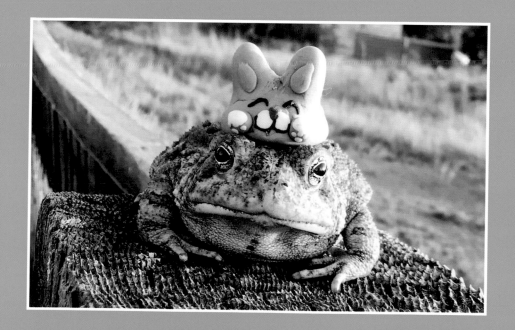

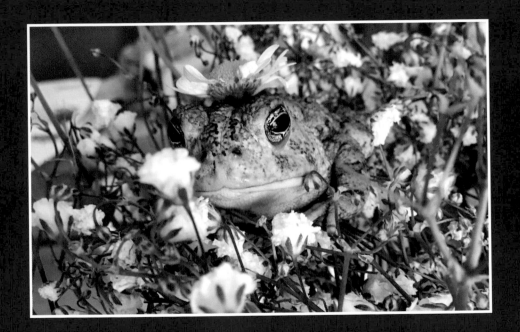

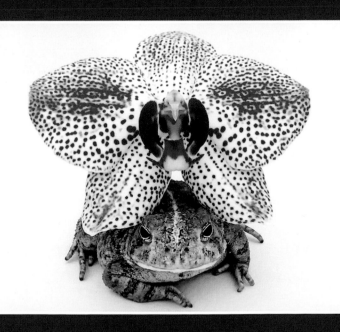

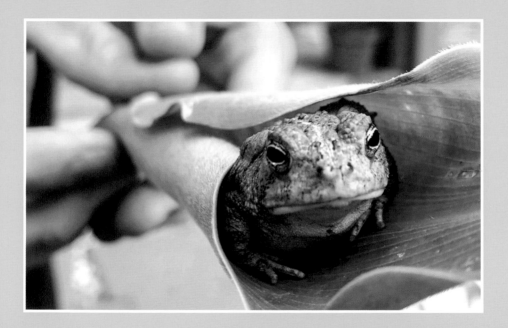

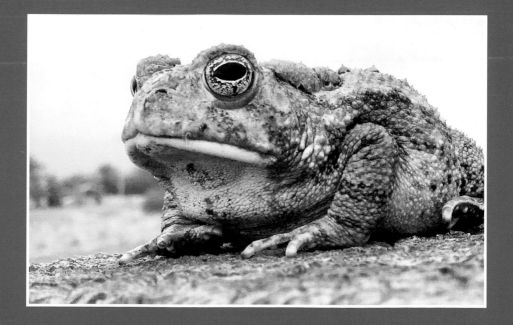

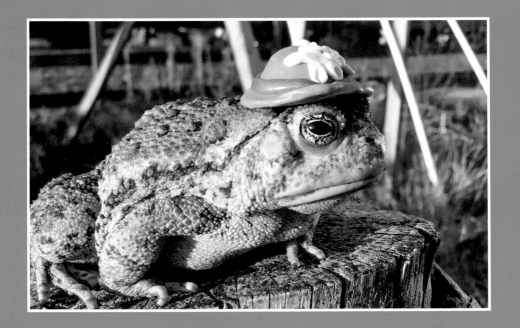

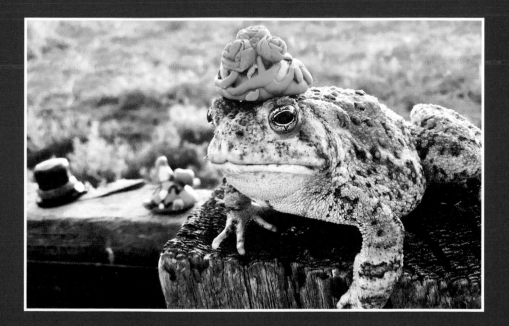

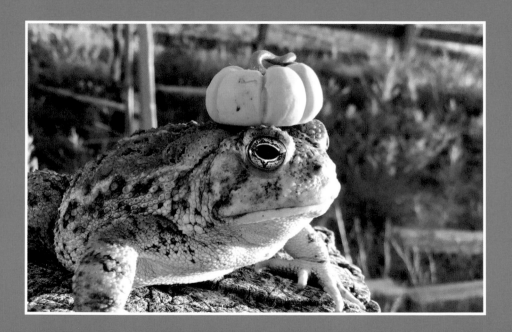

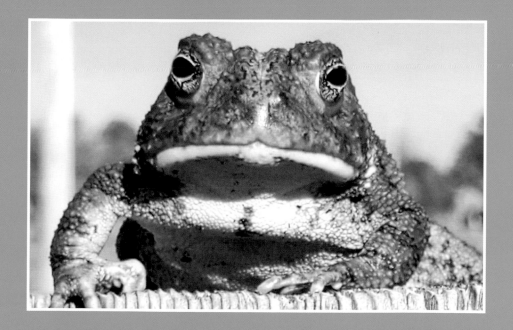

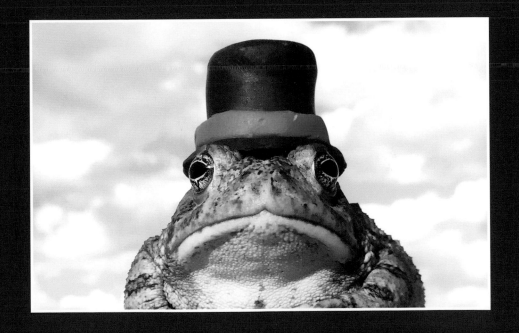

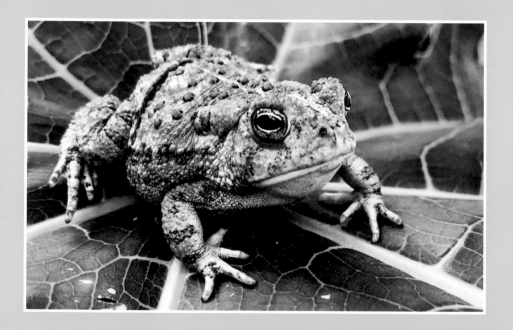

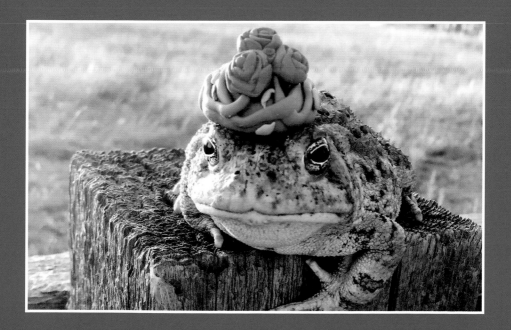

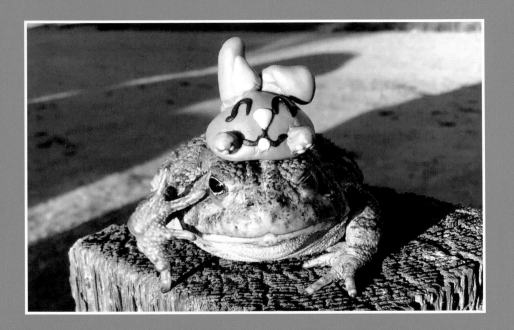

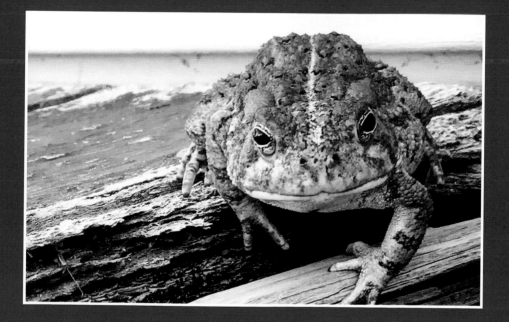

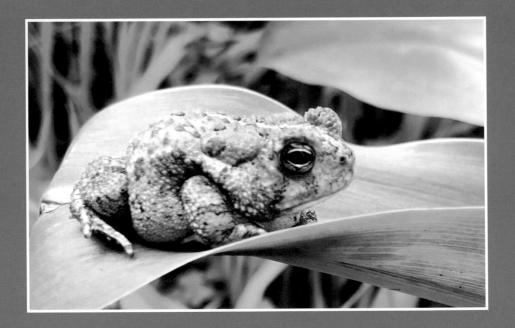

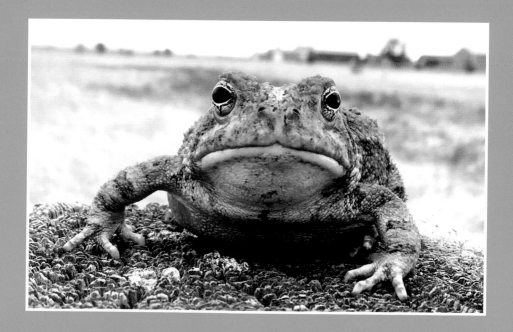

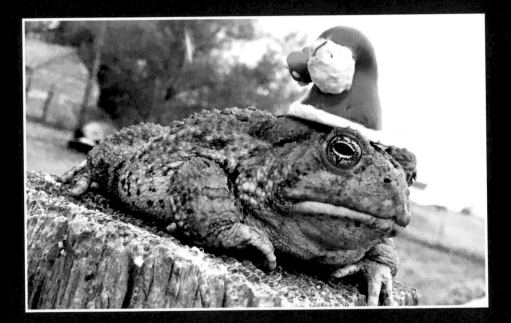

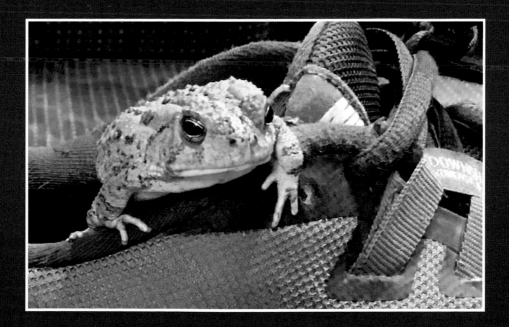

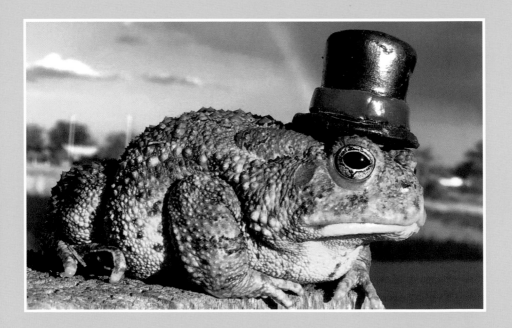

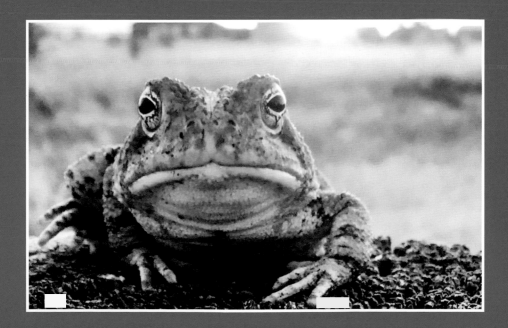

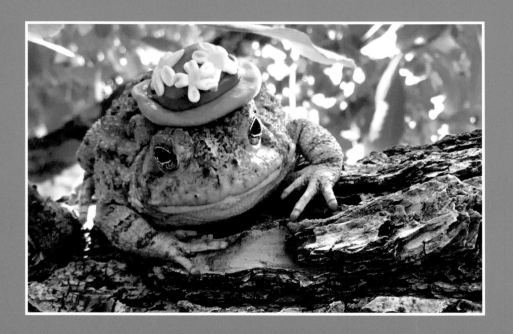

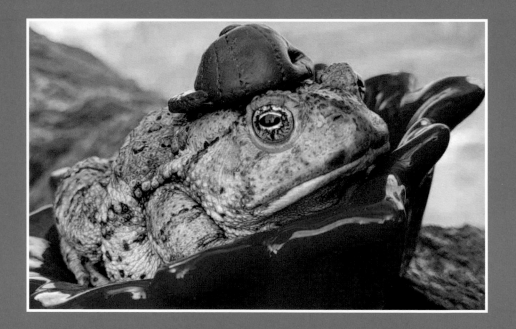

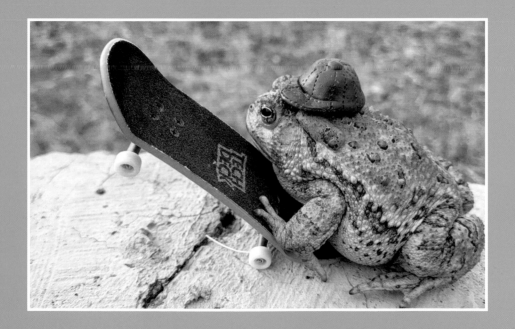

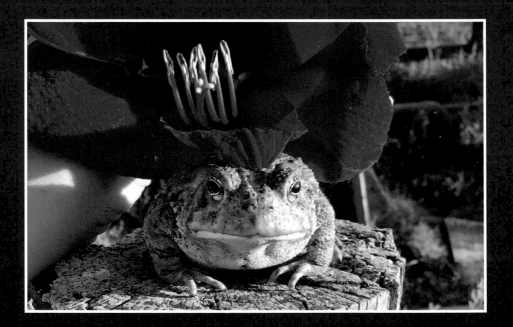

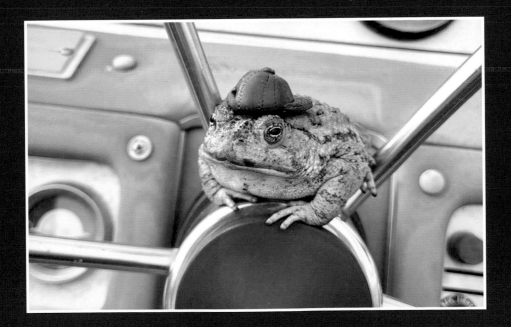

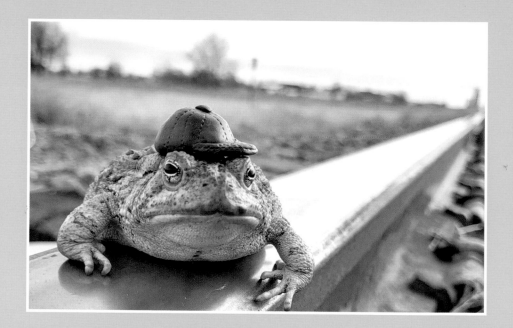

Bait the Toad's Top Style Tips for Toads

(Bait would like to stress that frogs and toads are entirely different—and while frogs must be kissed to become princes, toads are plenty royal on their own, thank you very much.)

- Toads are peculiar animals with a taste for bling and accessories. Primary on your shopping list for your toad should be fancy wear with an emphasis on headgear.

- Be sure to spoil your toad with flowers and greenery. They are especially fond of expensive orchids.

- Toads enjoy their leisure spaces (and their guests) to be fresh and uncluttered. Pay special attention towards keeping their homes clean, and be sure to wash and dress your best before greeting them.

- A toad's boudoir should be customized for the particular eccentricities of your amphibian. For example, if they delight in finery, there can never be enough lace.

- Bait the Toad's preference in sports is unlike the average amphibian who generally tend towards polo and yacht racing. If that is your toad's diversion of choice, be sure to find them accoutrements for their enjoyment.

- Toads are often fond of horse races. They exclusively bet on the chestnuts, but be careful to track their expenses as they are frivolous gamblers.

- I have yet to meet a toad who did not like champagne. They are allergic to mass-produced beer.

- A toad's style may change a dozen times before noon; one particular amphibious friend of Bait's has been known to sport soft pink claw polish, a spiked choker, and a baseball hat in a single ensemble.

- If you find your toad is struggling to deal with reality, an emotional support monkey or mink will take care of their distress.

- When all else fails, showing your toad this book will surely cheer them up.